YOU'RE WEIRD

A Creative Journal for Misfits, Oddballs, and Anyone Else Who's Uniquely Awesome

Kate Peterson

A TarcherPerigee Book

tarcherperigee

An imprint of Penguin Random House LLC
375 Hudson Street
New York, New York 10014

Most TarcherPerigee books are available at special quantity discounts for bulk purchase for sales
promotions, premiums, fund-raising, and educational needs. Special books or book excerpts also can
be created to fit specific needs. For details, write: SpecialMarkets@penguinrandomhouse.com.

Proprietary ISBN 9781101948682

Printed in the United States of America
5 7 9 10 8 6

FOR NATE,

my mutual weirdo

INSTRUCTIONS

Many writers will tell you that it's important to cultivate the right mood to get "in the zone" to write. Taking this to heart, here are some suggestions for how to get in the right mood to start writing in this journal:

- Put down this book, have a dance party, pick up this book, and open it.

- Tilt your head back, laugh maniacally, pick up this book, and open it.

- Silently raise your fist into the air, pause for a moment, lower your fist, pick up this book, and open it.

- Put this book down on the floor, walk to the other side of the room, frolic back to where this book is, pick up this book, and open it.

- Find a quiet space, sit comfortably, open your mouth, joyfully shout a steady stream of nonsense words, pick up this book, and open it.

Every page of this book was made for writing, drawing, coloring, and making a mess. You'll need a pen or pencil and whatever coloring implements you like best; otherwise, you've already got everything you'll need!

Carpe weird!

Kate
The strange creature who made this book

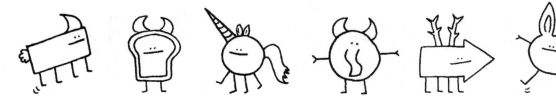

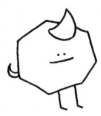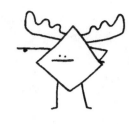

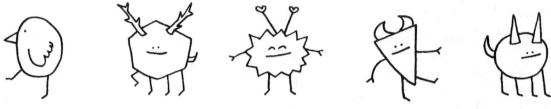

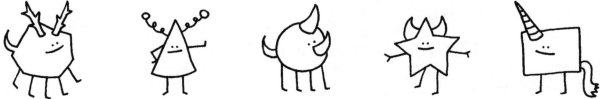

TWENTY QUESTIONS ABOUT THE

Name:

Nicknames:

Family members:

Closest friends:

Current job title:

Places lived:

Favorite places visited:

Current city:

Favorite local hangouts:

Favorite things to do:

WEIRDO WHO OWNS THIS BOOK?

Things done every day:

Favorite books:

Favorite movies:

Favorite bands:

Favorite foods:

Most prized possessions:

Areas of expertise:

Talents and skills:

Proudest accomplishments:

Biggest goals:

What does "weird" mean to you?

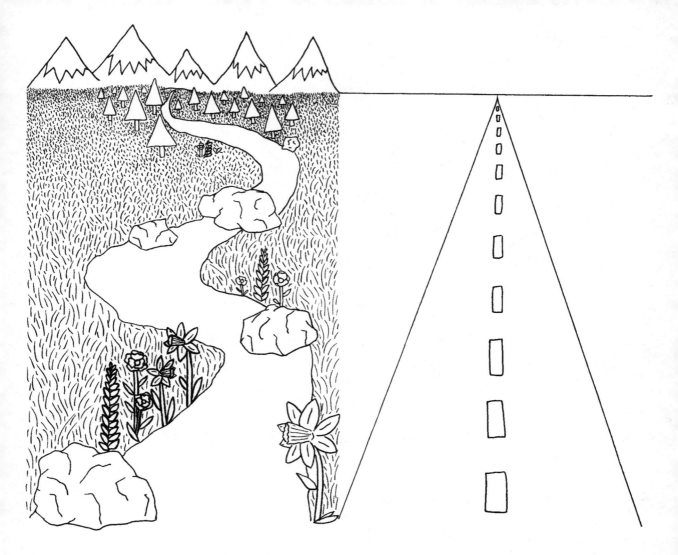

"NORMALITY IS A PAVED ROAD.
IT'S COMFORTABLE TO WALK,
BUT NO FLOWERS GROW ON IT."

- Vincent van Gogh

HERE'S WHAT'S UNIQUE ABOUT...

My home:

My family:

The way I was raised:

The country I live in:

The state I live in:

The city I live in:

My career:

How I got to where I am today:

My appearance:

My friends:

My sense of style:

The way I see the world:

IF I WERE A...

Based on your personality and characteristics, what kind of each of these categories would you be?

Drink:

Dance move:

Hat:

Shoe:

Ice cream flavor:

Pizza:

Cheese:

Fruit or vegetable:

Junk food:

Sandwich:

Mythical creature:

Musical instrument:

Toy:

Style of art:

Movie genre:

City:

Breakfast food:

Season:

Constellation:

Plant:

Car:

Color:

Write about someone you know who stands out from the crowd. What do you admire about them? What do you think it's like to be in their skin?

BUILD YOUR OWN SPIRIT ANIMAL

Your spirit animal is the animal who best represents your characteristics and personality; but, being the weirdos we are, why limit ourselves to animals that already exist? Combine these animal building blocks or create your own from scratch to capture your particular brand of peculiarity.

horns & antlers:

tails:

ears:

noses:

feet:

RANDOM ACTS OF WEIRDNESS CHALLENGE

LEVEL 1

☐ Have a dance party all by yourself.

☐ Wear some seriously funky socks.

☐ Make a mess on purpose.

☐ Use chalk to write a quote about weirdness on a high-traffic sidewalk.

☐ Write silly jokes on postcards and send them to your friends.

#randomactsofweirdnesschallenge

MAJORITY REPORT

When do you fly solo and when do find yourself in a crowd? Fill in the blanks to see where you find yourself in good company and where you stand alone.

Some people _____, but
I _____.

While most people never _____,
I _____.

Like most other people, I _____
_____.

I hate being the only one who _____
_____.

I love being the only one who _____
_____.

I strongly agree with the popular belief that _____
_____.

I strongly disagree with the popular belief that _____
_____.

YOUR MISSION, SHOULD YOU CHOOSE TO ACCEPT IT

What's your mission for this weird and wonderful life?

What were you taught about individuality as you were growing up?

BE THE STRANGE YOU WISH TO SEE IN THE WORLD

Fill this page with the weirdness you want to be, see, and set free!

BIZARRE TRENDS FROM THE WEIRD DECADE I GREW UP IN

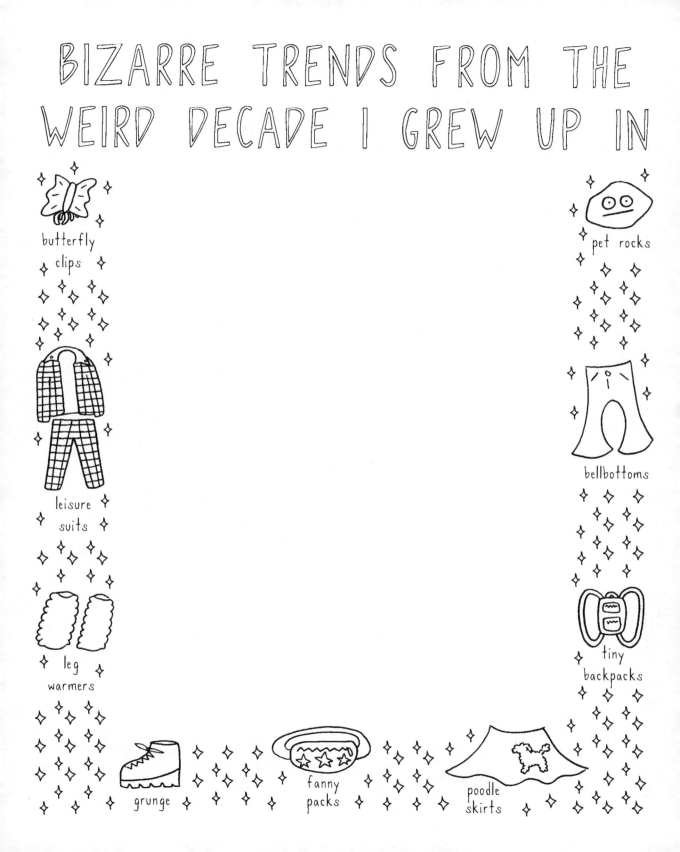

butterfly clips

pet rocks

leisure suits

bellbottoms

leg warmers

tiny backpacks

grunge

fanny packs

poodle skirts

MY FAMILY'S WEIRDEST TRADITIONS

All normal families are alike; each weird family is weird in its own way.

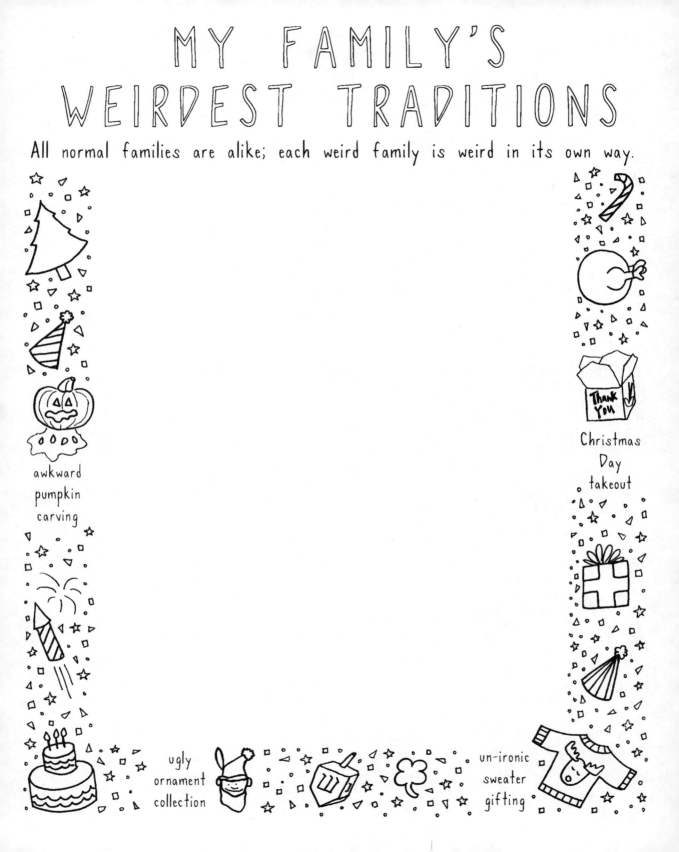

awkward
pumpkin
carving

Christmas
Day
takeout

ugly
ornament
collection

un-ironic
sweater
gifting

MY WEIRD HOMETOWN

Every seemingly normal town has a hidden layer of quirkiness. What makes the town you grew up in weird?

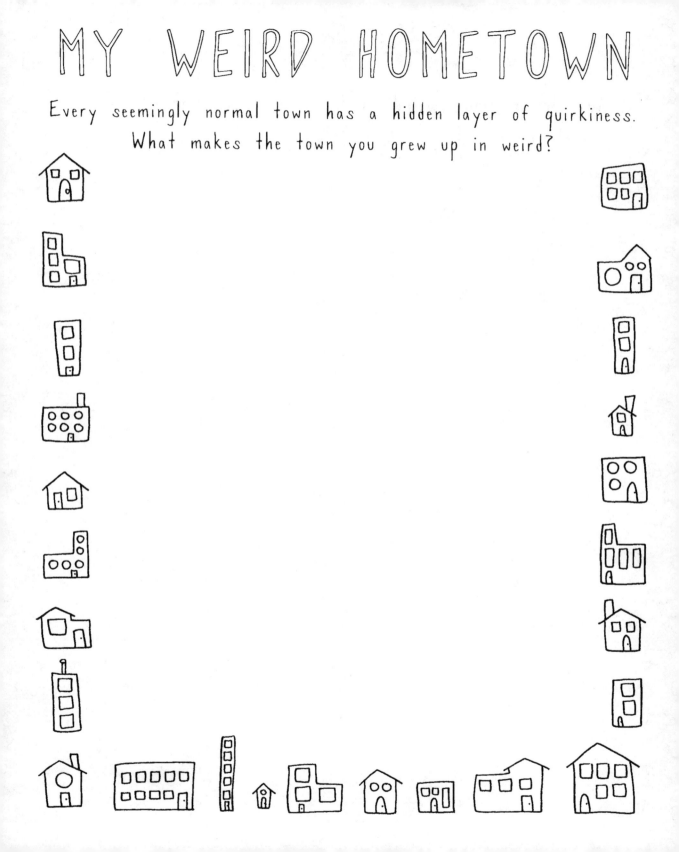

Which of your weird qualities did you inherit, and which ones did you learn?

THE WEIRDEST THINGS
I DID WHEN I WAS A KID

No judgment. (Just suppressed giggles.)

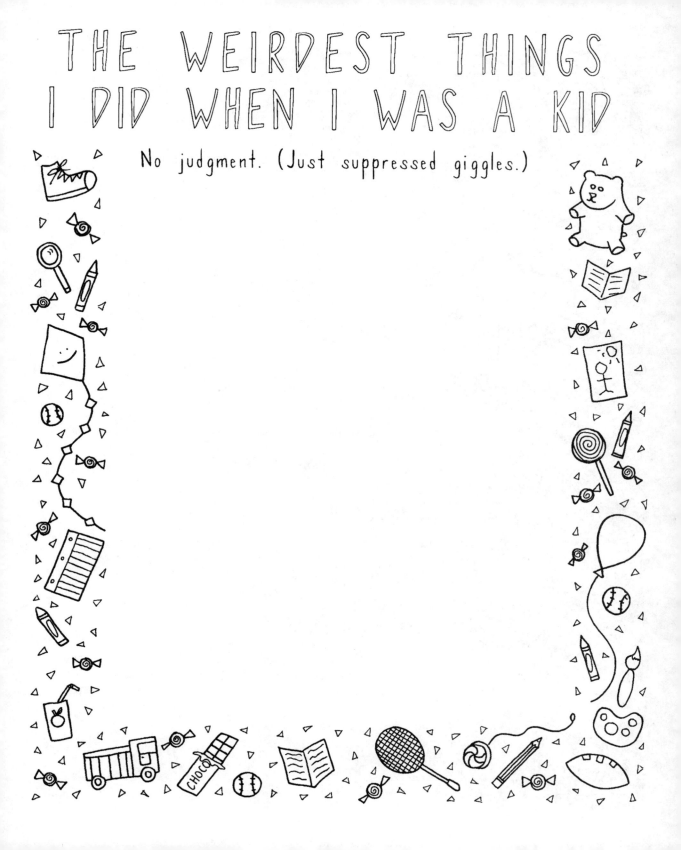

Draw an apple that will fall reeeeeally far from the tree.

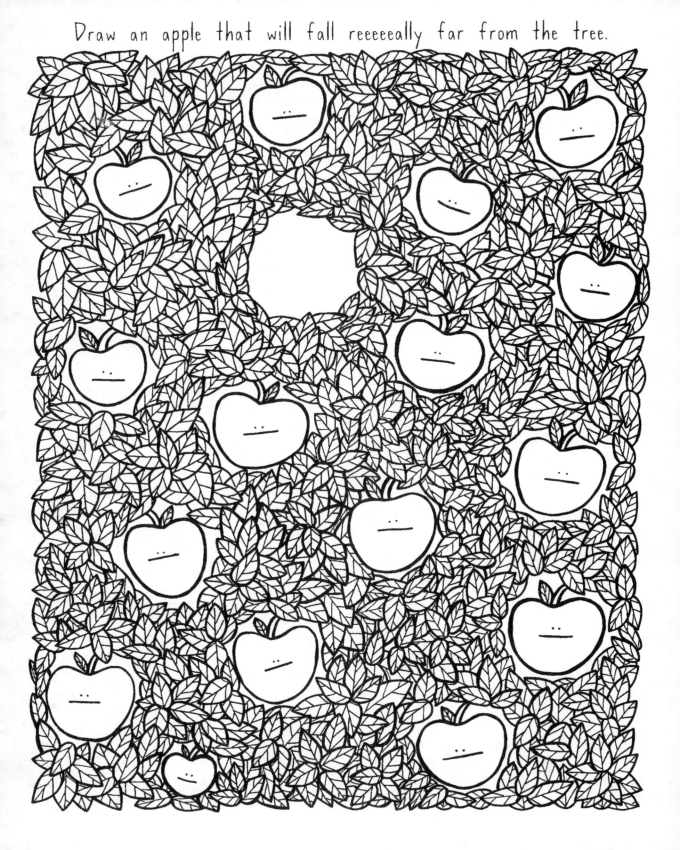

AN ODDBALL IS BORN

What were the most pivotal events, conversations, and situations that shaped you into the strange creature you are now?

What kind of role model did you need when you were younger?
How can you be that role model for someone else?

IT TAKES A VILLAGE
TO RAISE A WEIRDO

Who were the most influential figures in your village?

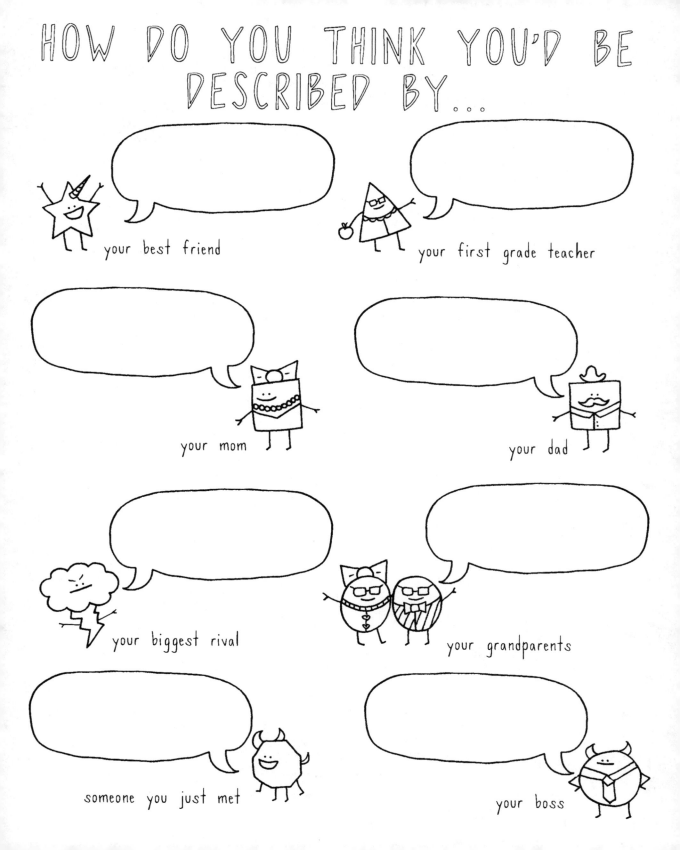

Think back to a moment when you felt out of place as a child. What would you tell your younger self now?

I'm not quite
sure what I am.

5 WORDS TO DESCRIBE MYSELF AT AGE...

Once you get past the present, choose 5 words that describe what you hope you'll be like at that age. (Spoiler alert: weirdness and awesomeness ahead.)

5:

10:

15:

20:

25:

30:

40:

50:

60:

70:

80:

90:

Do you think you FIND yourself as you grow older, or CREATE yourself as you grow older?

"IT'S WEIRD NOT TO BE WEIRD."

- JOHN LENNON

Black sheep welcome here! Add a few oddballs to this flock.

FAVORITE WEIRDOS
FROM BOOKS
(Fictional or real!)

Name	What makes them weird?	Why is their weirdness awesome?

I THINK YOU'RE WEIRD.
LET'S BE FRIENDS.

Fill in the speech bubbles with compliments. Human points achieved!

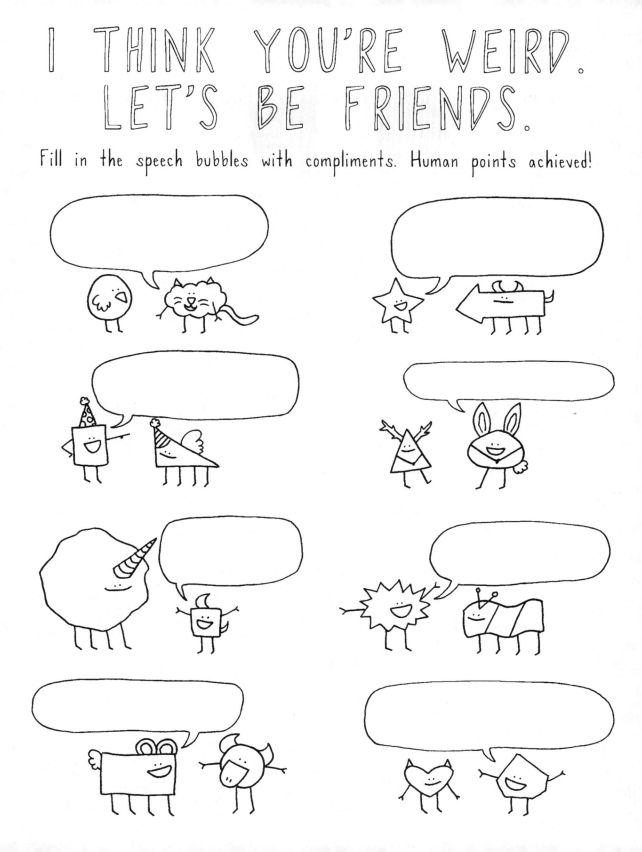

What kinds of weirdness are most important to you in a partner?

AND THE AWARD GOES TO...

The weirdest thing I've ever eaten:

The weirdest place I've ever been to:

The weirdest conversation I've ever had:

The weirdest date I've ever been on:

The weirdest thing I've ever seen in a public place:

The weirdest thing I've ever done in a public place:

The weirdest movie I've ever seen:

The weirdest book I've ever read:

(Think of this as your personal
Guinness Book of Weirdness Records.)

The weirdest piece of clothing I've ever worn:

The weirdest idea I've ever had:

The weirdest thing I've ever said out loud:

The weirdest thing I've ever seen in a big city:

The weirdest thing I've ever seen in the great outdoors:

The weirdest thing I've ever done with my friends:

The weirdest thing I've ever done with my family:

The weirdest thing I've ever done while alone:

Pick one of your favorite unique attributes.
What would your life be like without it?

THIS, THAT, OR

Leader, follower, or _____

Introvert, extrovert, or _____

Adventure, caution, or _____

Glass half full, half empty, or _____

Truth, dare, or _____

Lover, fighter, or _____

Messy, neat, or _____

Spontaneous, planned, or _____

City, country, or _____

Cats, dogs, or _____

Hot, cold, or _____

Car, plane, or _____

Walk, run, or _____

Books, movies, or _____

Fiction, non-fiction, or _____

Morning, night, or _____

Winter, summer, or _____

Spring, fall, or _____

Sunrise, sunset, or _____

Sun, moon, or _____

Oceans, mountains, or _____

Trees, flowers, or _____

SOMETHING WEIRD

Call, text, or _____

Teacher, student, or _____

Pen, pencil, or _____

Crossword, sudoku, or _____

Black, white, or _____

Classic, modern, or _____

Detailed, abstract, or _____

New, vintage, or _____

Salty, sweet, or _____

Chocolate, vanilla, or _____

Scrambled, fried, or _____

Spicy, mild, or _____

Cake, pie, or _____

Peanut butter, jelly, or _____

Burgers, hot dogs, or _____

Ketchup, mustard, or _____

Salt, pepper, or _____

Pancakes, waffles, or _____

Coffee, tea, or _____

Beer, wine, or _____

Shaken, stirred, or _____

"DARE TO DIFFER."

— Matthew Goldfinger

MY FAVORITE WEIRD WORDS

bubble * shenanigans * tchotchke * funk * balderdash * oaf * hubbub * purloue * mooch * hullabaloo * brouhaha * bombastic * mugwump * pumpernickel * strumpet * cattywampus

snarf * slaphappy * hamfisted * fustigate * anemone * hobgoblin * conundrum * curmudgeon * queue * guffaw * chortle * syzygy * yodel * gumbo * jamboree * blubber * gibberish

honeyfuggle * collywobbles * argle-bargle * blatherskite * chanticleer * gazebo
pouch * persnickety * rhubarb * kerfuffle * quixotic * bamboozle * quip * quidnunc

If your weirdness had a logo and a slogan, what would they be?

silliness is
next to
awesomeliness

DRAW YOUR WEIRD DREAM HOUSE

A spiral slide instead of a spiral staircase? Check. A castle turret full of books and wine? Yes please. An oven with the capacity to cook twenty pizzas simultaneously? Nailed it.

snow globes

fantastic socks

vintage cookbooks

souvenirs

MY WEIRD STUFF

What are the weirdest objects you own? Bonus points for odd thrift store finds, handmade heirlooms, and funky old furniture. (Deduct points for any and all clown figurines.)

gnomes

terrifying nutcrackers

this book

very special sweaters

WEIRDOS INVITED

Make a list of odd theme parties to throw. BYOWeirdness!

Jam Jamboree

Blooper Bowl Sunday

Franksgiving

Pillow Fort Fest

Spectacle Spectacular

Cheeseapalooza

Pen Palentine's Day

Make faces on this page! If you use pen, they'll get stuck that way.

"WHEN IN DOUBT,
MAKE FUNNY FACES."

– Amy Poehler

Weird friends for the win! What unique traits
do you admire in your friends?

PEOPLE IT'S EASY TO BE MYSELF AROUND

Birds of a freakish feather flock together.

PLACES WHERE IT'S EASY TO BE MYSELF

The grass is greener on the offbeat side.

How do you share your weirdness on social media?

DRAW A WEIRD SELFIE

(Bonus points for posting it with #myweirdselfie!)

DECORATE THESE HATS AS STRANGELY AND SPECTACULARLY AS YOU CAN

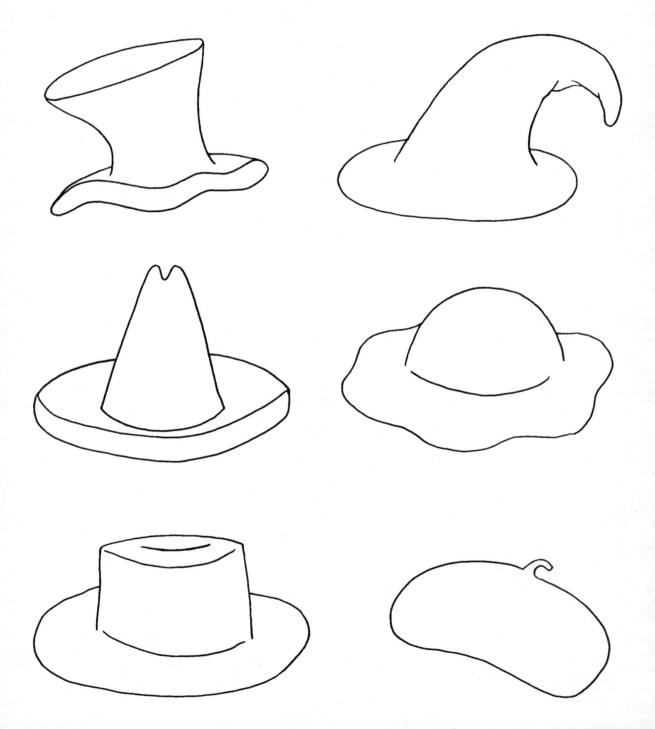

GIVE YOURSELF STAGE NAMES

Because alter ids are way better than alter egos.

Rock star:

Literary pen name:

Movie star:

Rapper:

Pirate:

Wrestler:

Drag queen:

Country star:

Superhero:

Supervillain:

Imagine you just started writing to a pen pal you've never met before. Write an introduction that tells them everything you want them to know about you.

Honestly, I dream about cheese almost every night.

FAVORITE WEIRDOS
FROM MOVIES

(Fictional or real!)

Name	What makes them weird?	Why is their weirdness awesome?

THE MOVIE OF YOUR LIFE

Who plays you?

Who are your costars?

Is there a villain?

Where will it be filmed?

What shocking plot twists occur?

What pivotal scene will win the lead actor an Oscar?

What's on the blooper reel?

What does the poster look like?

Who and what brings out the best in you, and what does the best in you look like?

RANDOM ACTS of WEIRDNESS CHALLENGE

LEVEL 2

- ☐ Order dessert first.

- ☐ Make up a word and try to slip it into three different conversations without anyone noticing.

- ☐ Have a conversation in an accent you don't actually have.

- ☐ Give a goofy fake name when you order coffee.

- ☐ Write haikus about different foods on sticky notes, go to the grocery store, and leave them on or near those foods in the store.

#randomactsofweirdnesschallenge

DRAW A SELF-PORTRAIT WITH YOUR NON-DOMINANT HAND

(Because who wants to take themselves too seriously, anyway?)

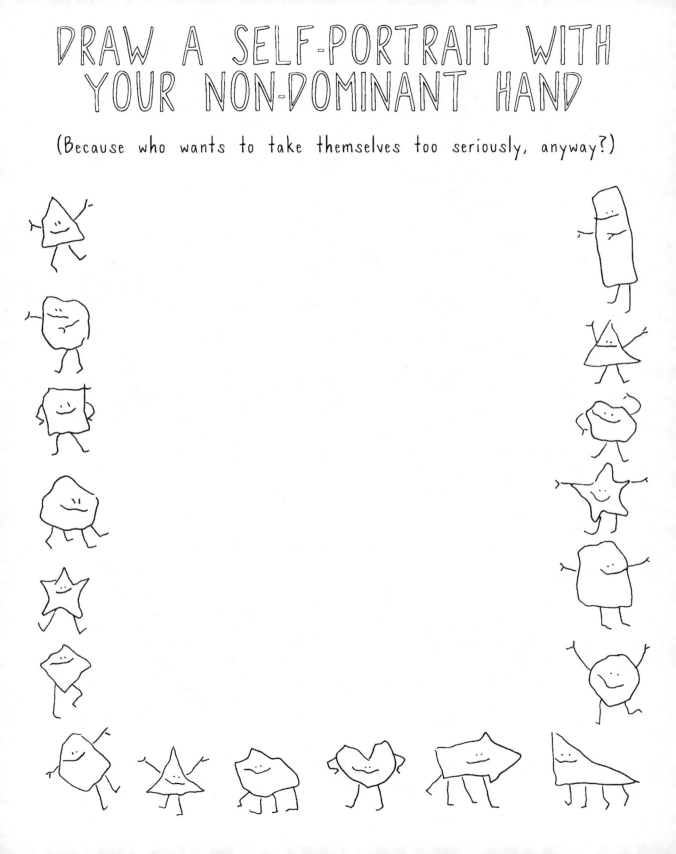

HERE'S MY HEART.

Of all the things that make up this weird world we live in, what do you care about most in that odd little heart of yours? Label each section with something you hold dear.

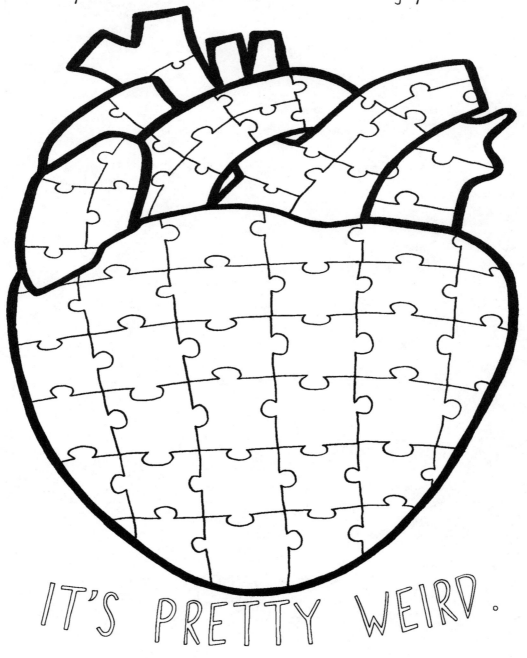

IT'S PRETTY WEIRD.

What do you think about in that peculiar brain you've got inside your head? Label each section below with the things you find yourself thinking about the most.

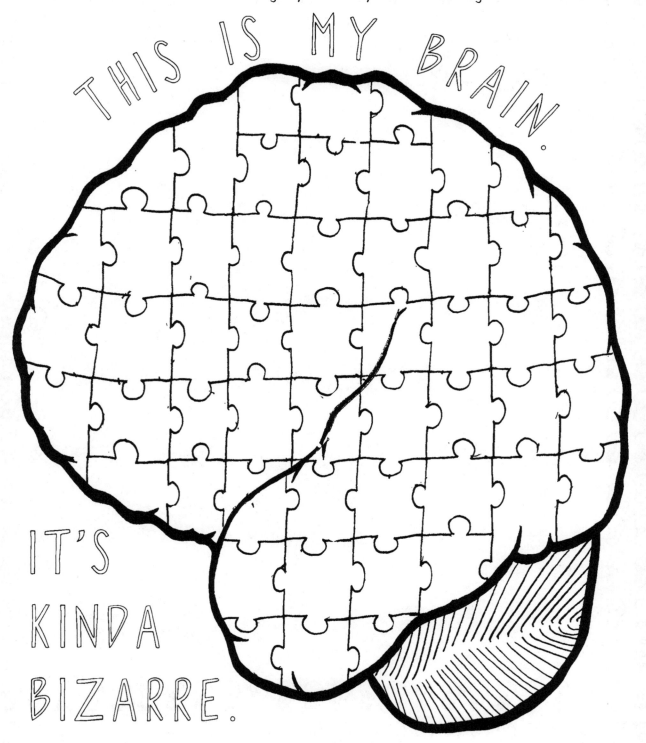

THIS IS MY BRAIN.

IT'S KINDA BIZARRE.

What happens in your head that doesn't happen out loud? Why not?

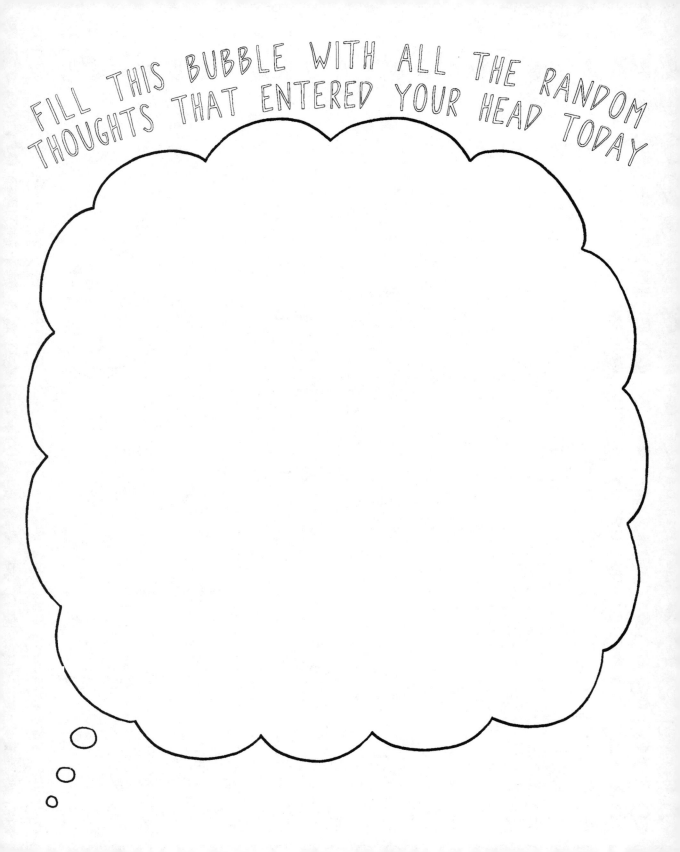

THINGS I'VE THOUGHT ABOUT THAT MOST OTHER PEOPLE HAVE PROBABLY NEVER THOUGHT ABOUT

What did Yankee Doodle call macaroni? His pony? His hat?
His feather? #manofmystery

THESE PAGES ARE FOR DOODLING AND MARVELING AT

ALL THE THINGS THAT COME OUT OF YOUR BRAIN

Think back to a time when you were true to yourself despite the circumstances. How did it feel at the time, and how do you feel looking back on it now?

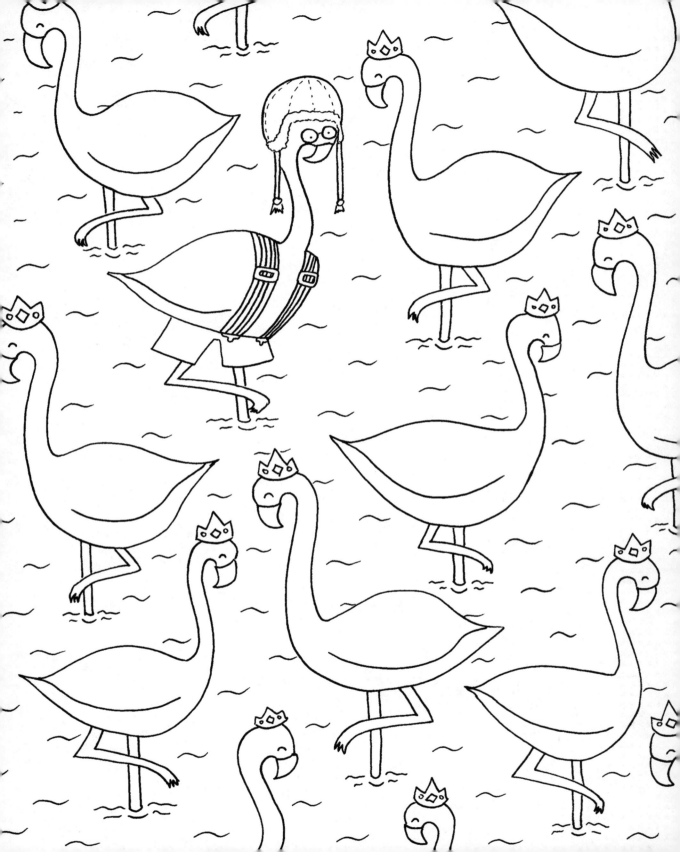

YOUR WEIRD COAT OF ARMS

Draw and color four things you choose to represent your odd self in the spaces on the shield. Share your weirdness with #myweirdcoatofarms!

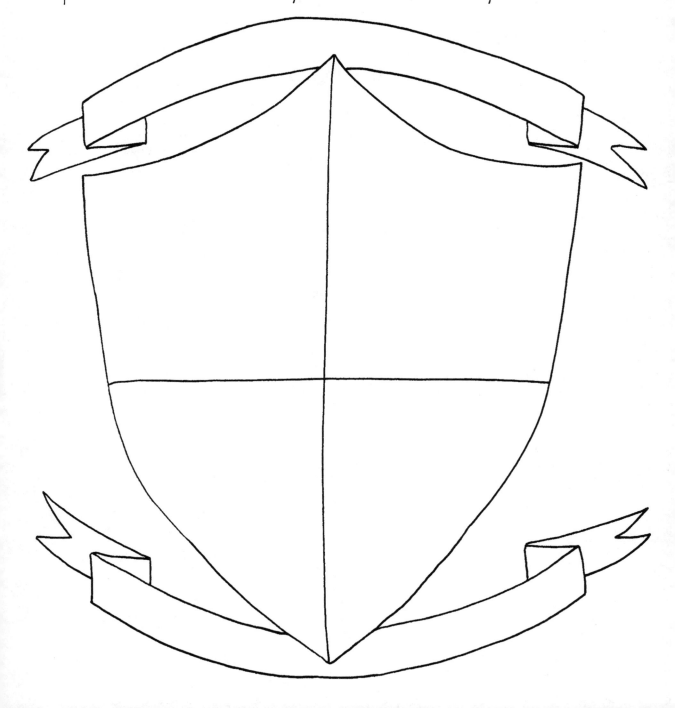

QUOTES THAT SPEAK TO ME

"Whatever makes you weird is probably your greatest asset."
- Joss Whedon

FILL THESE PAGES WITH QUOTES THAT STRIKE A CHORD IN THE WEIRD KEY OF YOUR LIFE

"There is no exquisite beauty...without some strangeness in the proportion."
- Edgar Allan Poe

Do you think "normal" exists?

These are my sassy pants.

DRAW A CRAZY DREAM YOU'VE HAD...

...AND NOW DRAW A CRAZY DREAM YOU'D LIKE TO HAVE

ME: THE OFFICIAL SOUNDTRACK

What songs are on the playlist of your offbeat life?

SONG LYRICS ABOUT BEING A STRANGE CREATURE

What lyrics make you want to march to the beat of your own drum?

What, if anything, prevents you from being your authentic self?

radiate

BUILD YOUR OWN MOTTO

Underline the words that speak to you. Then, fill your favorites into the blanks on the opposite page to create your own quirky motto, or go rogue and come up with your own from scratch.

NOUNS:

greatness, laughter, power, creativity, intelligence, fun, joy, happiness, travel, pizza, shenanigans, hootenanny, coffee, attitude, peace, world, nature, adventure, burrito, voyage, expedition, exploration, imagination, thought, caffeine, sandwich, unicorn, beauty, uniqueness, home, weirdness, dreams, magic, change, wonder, pride, discipline, friendship, family, home, cats, dogs, music, party, coffee, honesty, diversity, strength, ambition, food, personality, energy, love, brilliance, knowledge

VERBS:

seize, create, make, find, conquer, work, play, believe, think, go, move, run, rock, explore, build, write, draw, capture, plant, adore, imagine, think, forge, be, mind, try, get, shine, care, dance, sing, take, achieve, win, choose, fill, exercise, push, celebrate, laugh, talk, walk, stay, call, add, adapt, simplify, give, collect, discover, help, guide, pioneer, succeed, paint, boogie, skip, leap, invent, grab, open, read, smile, cook, pursue, listen, shout, love, cultivate, grow, frolic, giggle

"_____ the _____"

"_____ every day with _____"

"There can be no _____ without _____"

"Find _____ in the _____"

"_____ the _____ you wish to see in the world"

"Say yes to _____"

"Dance to the _____ of your own _____"

"_____s aren't born, they're _____"

"_____ it with _____ or not at all"

"_____, _____, _____"

OR WRITE YOUR OWN FROM SCRATCH:

MAKE A MOTTO COLLAGE

Write your shiny new motto on this page and fill it with clippings of words, photos, and whatever else represents your new words to live by.

WHAT I VALUE ABOVE ALL ELSE

Fill this page with all the strange and lovely things you give the most hoots about.

I am happiest in my own skin when...

one of
a kind

THINGS TO BE GRATEFUL FOR IN MY WEIRD, MESSY, AWESOME LIFE

Fill this page with all the things that make you feel like the luckiest living soul in all the land.

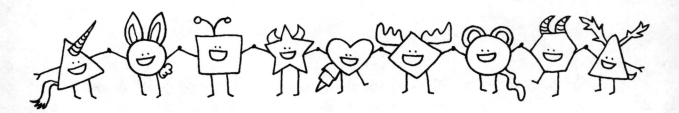

DRAW YOUR FREAK FLAG

Ever heard the phrase "let your freak flag fly"? Well, now's your chance, you magnificent unique snowflake.

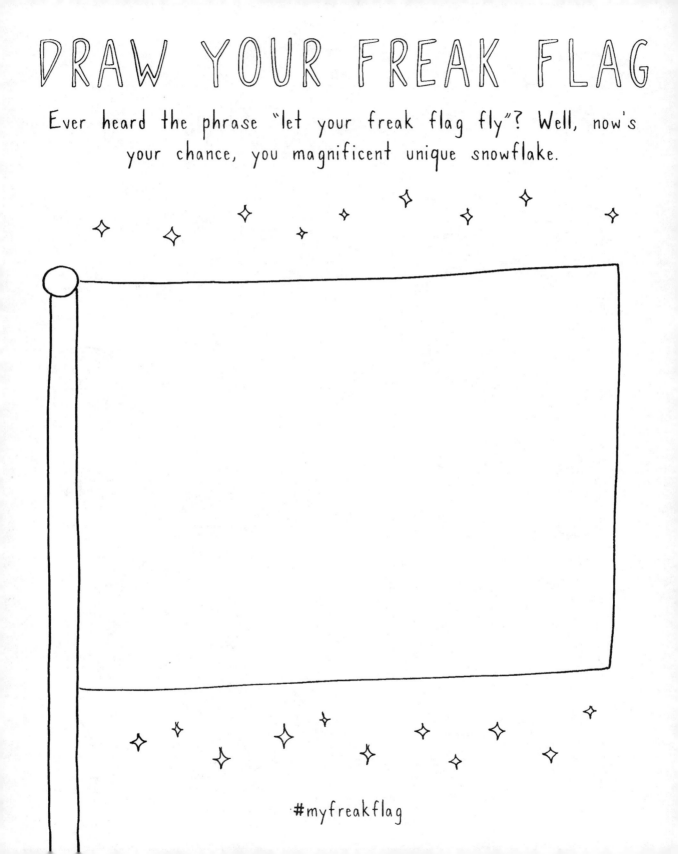

#myfreakflag

 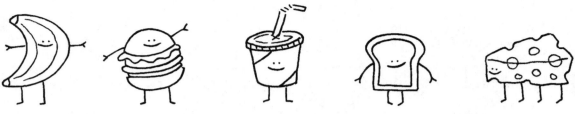

MY WEIRD SUPERPOWERS

What are you freaky-good at?

opening jars

imitating animal calls

winning at rock, paper, scissors

making perfectly round pancakes

untying knots

estimating distances

How do you turn things around when you're feeling down on yourself?

It's not easy being a sardine.

dogs
in
costumes

new
socks

cloud
shapes

RANDOM THINGS THAT
MAKE ME SMILE

strong
coffee

pudgy
animals

miniature
foods

GIVE THESE HEADS SOME SERIOUSLY WEIRD HAIRSTYLES

What would the world be like if everyone was the same?

REWRITE IT

Little girls can be made of whatever they want. Shut it down.

A man's home is his castle.

An apple a day keeps the doctor away.

Better safe than sorry.

Cleanliness is next to godliness.

Curiosity killed the cat.

Diligence is the mother of good fortune.

Nothing is certain but death and taxes.

Opportunity seldom knocks twice.

Sugar and spice and everything nice; that's what little girls are made of.

The grass is always greener on the other side of the fence.

You can't have your cake and eat it too.

COLOR OUTSIDE THE LINES ON THIS PAGE

FAVORITE WEIRDOS
FROM MUSIC & ART

Name	What makes them weird?	Why is their weirdness awesome?

Imagine that, for one whole day, no one would know about anything you did. How would you fill up that day?

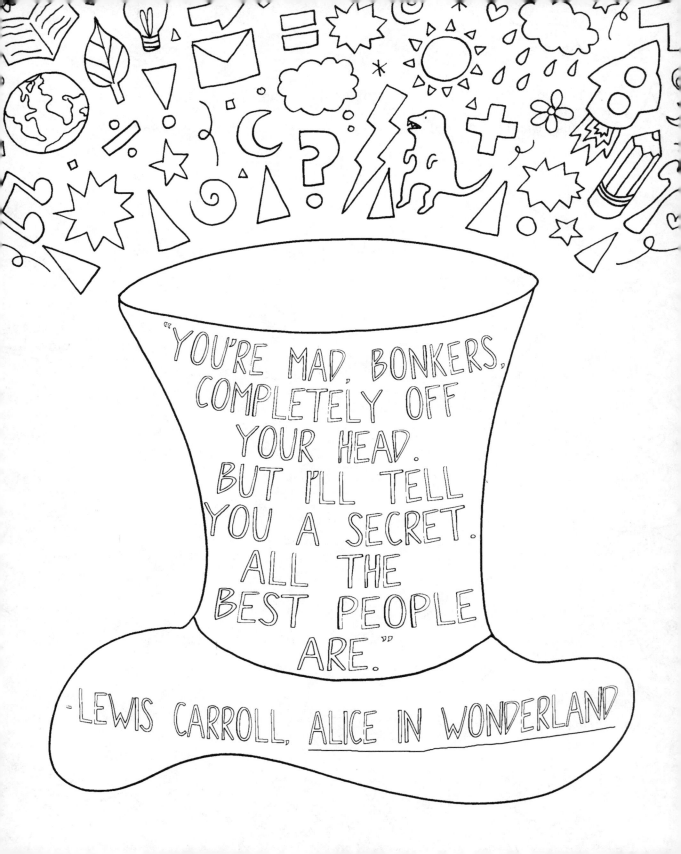

DRAW A MAP OF YOUR COMFORT ZONE

That first step is a doozy, but the journey of a thousand miles starts with a little pep.

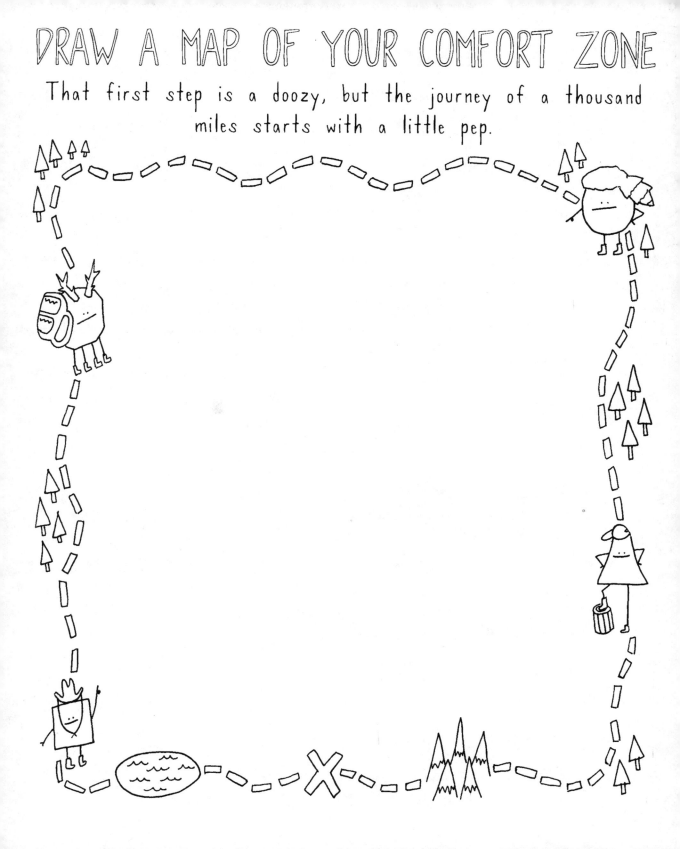

Sit in a park, coffee shop, or other public place and make note of the little oddities you see around you.

THE WEIRDEST THINGS I'VE OVERHEARD IN PUBLIC

(Pro tip: subways and buses, twenty-four-hour diners, and tiny towns are gold mines for weirdness.)

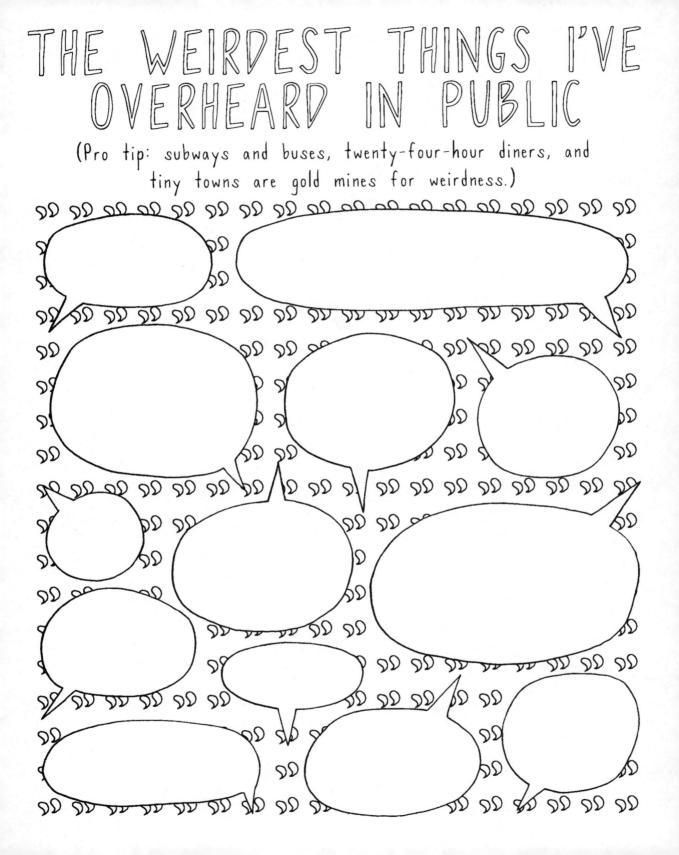

FORTUNE FAVORS THE WEIRD

What ridiculous message would you want to find inside a fortune cookie? What would you want to tell someone else in theirs?

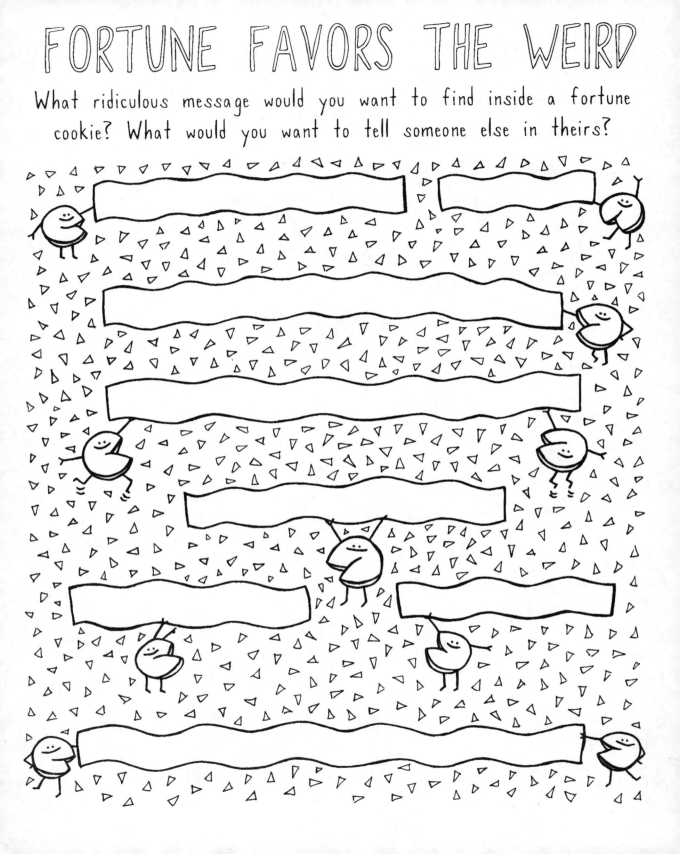

"IF EVERYONE IS THINKING ALIKE, THEN SOMEBODY ISN'T THINKING."

— General George S. Patton

What are the rules? Which ones do you want to break?

WEIRD CONSTELLATIONS

(We should surely have a Pizza Major by now, right?)

MY WEIRD BUCKET LIST:

twenty strange things to do before I die

1.

2.

3.

4.

5.

6.

7.

8.

9.

10.

11.

12.

13.

14.

15.

16.

17.

18.

19.

20.

What do you do differently from people older than you?

What do you do differently from people younger than you?

What do you do differently from people your own age?

two peas in an odd pod

FREAK OF NATURE

Fill this page with things you see that prove Mother Nature's a weirdo too.

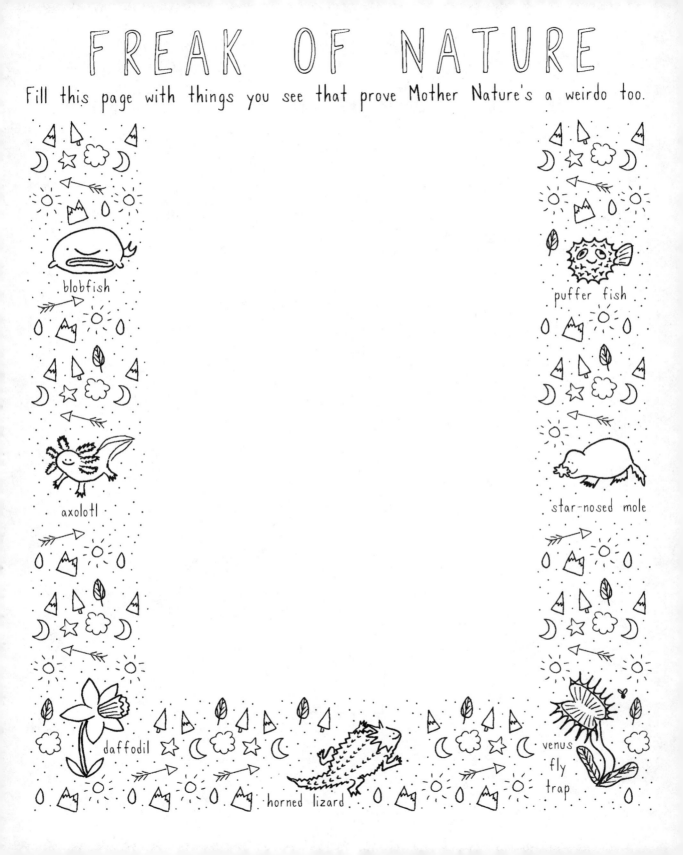

blobfish

puffer fish

axolotl

star-nosed mole

daffodil

horned lizard

venus fly trap

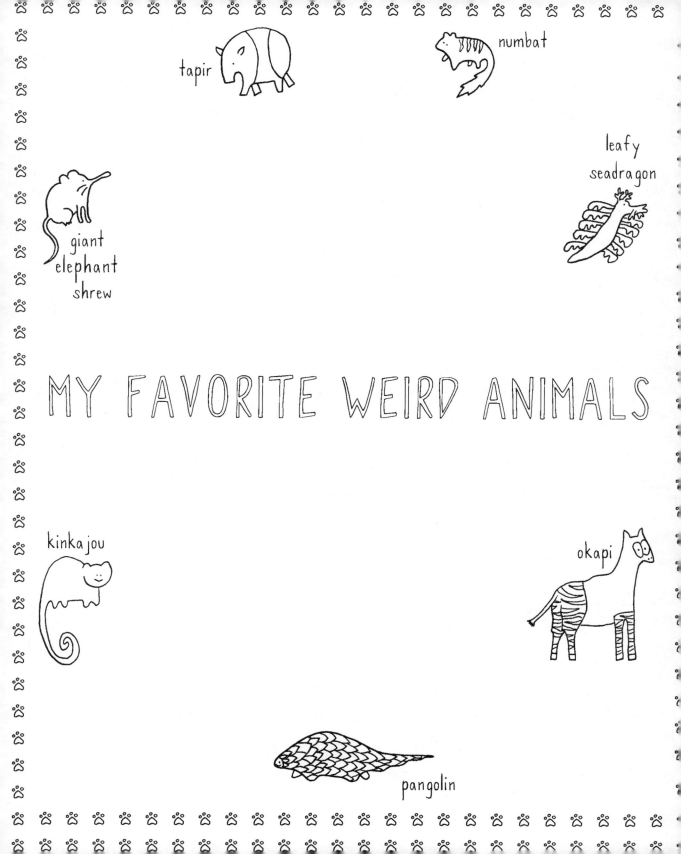

tapir

numbat

leafy seadragon

giant elephant shrew

MY FAVORITE WEIRD ANIMALS

kinkajou

okapi

pangolin

BIZARRE FACTS I'VE LEARNED ABOUT THE WORLD

Ooh, baby, it's a weird world.

FACT: there are over
1 million ants for
every person on the planet.

FACT: Scotland's
national animal
is the unicorn.

FACT: light doesn't
always travel
at the speed of light.

EXPERT-LEVEL WEIRD

Pick something in this weird world you've always wanted to know more about and become an expert on it!

Topic:

Facts you've learned about it:

How can you use your awesome new knowledge?

How do you think the world would be different if everyone was proud to be weird?

prance like
nobody's
watching

World
Sweater Weather
Appreciation
Day

Global Pizza
Party Day

WORLD HOLIDAYS WE'D ALL
CELEBRATE IF I WAS IN CHARGE

Take Your
Sweatpants
to Work Day

Breakfast for
Dinner Day

International Movie Marathon Day

Congratulations! You've just been put in charge of a new country. How will you rule over your dominion?

Name of country:

Your title as leader:

National anthem title:

Most important national holiday:

Customary greeting:

National dish:

National animal:

Poet laureate:

National sport:

Rights granted to all citizens:

How do you think your quirks will change
as you get older?

weird and wonderful
things are happening
in the world right now

FAVORITE WEIRDOS
FROM HISTORY

Name	What makes them weird?	Why is their weirdness awesome?

THE CRAZIEST THING I'VE EVER DONE FOR...

Love:

Friendship:

Family:

Work:

School:

Money:

My health:

The heck of it:

PERMISSION SLIPS, FROM YOU TO YOU

_____ is hereby granted permission to sing in the shower and/or car as loud as she or he likes, and without regard to the artistic merit or popularity of the songs chosen, from this day forward. Signed: _____

_____ is hereby granted permission to be as peculiar, quirky, strange, wacky, and weird as he or she pleases, from this day forward. Signed: _____

_____ is hereby granted permission to wear whatever odd pieces of fabric strike his or her fancy, which shall include cases where said outfit brings him or her joy while evoking the disapproval of others, especially parental units, and shall also encompass emergencies created by shortages of clean laundry. Signed: _____

_____ is hereby granted permission to be curious and excited and knowledgeable about whatever aspects of the world he or she wishes to get super nerdy about, and is granted permission to be as unapologetically enthusiastic about said topics as he or she desires. Signed: _____

_____ is hereby granted permission to feel awesome about her or himself. No questions asked. No judgment passed. Signed: _____

_____ is hereby
granted permission to _____

_____ from this day forward.
Signed:_____

_____ is hereby
granted permission to _____

_____ from this day forward.
Signed:_____

_____ is hereby
granted permission to _____

_____ from this day forward.
Signed:_____

_____ is hereby
granted permission to _____

_____ from this day forward.
Signed:_____

THE MOST OFF-THE-BEATEN-PATH PLACES I WANT TO VISIT

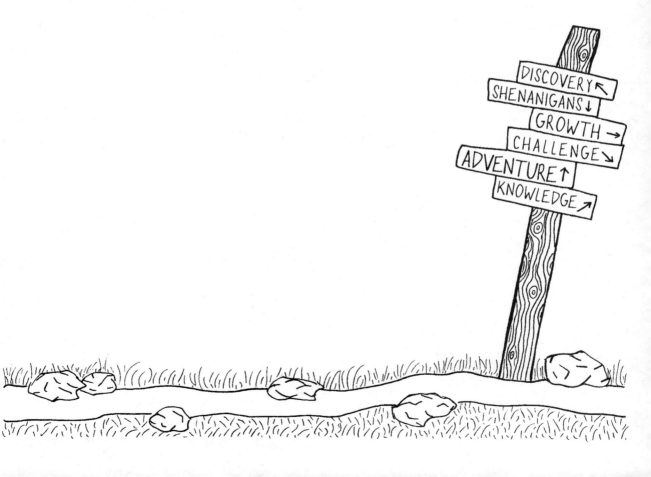

How can you use your weirdness for good?

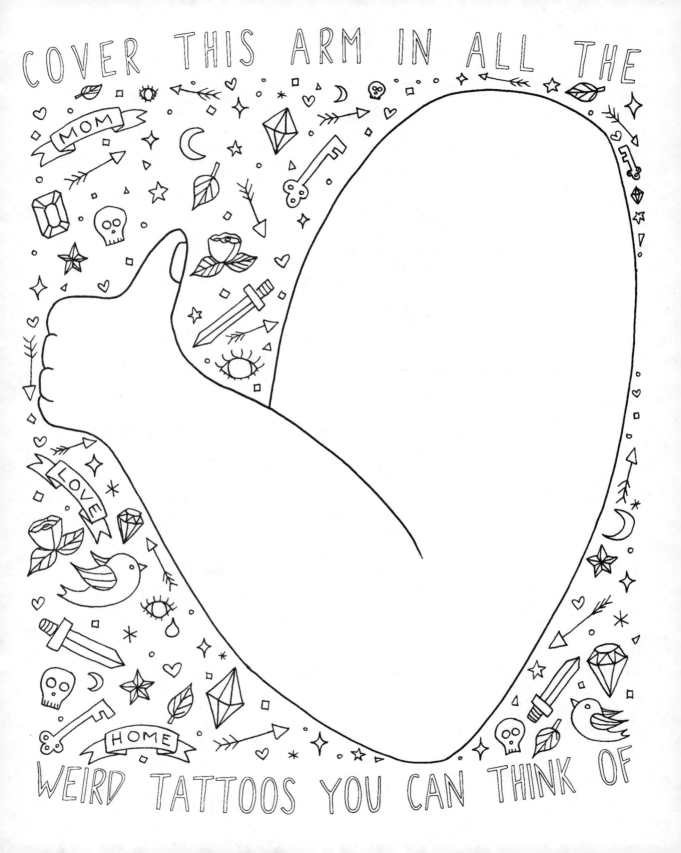

RANDOM ACTS OF WEIRDNESS CHALLENGE

LEVEL 3

☐ Dance in any public setting where you are the only one dancing.

☐ Eat a hot dog with chopsticks.

☐ Go to a thrift store with a friend. Pick out ridiculous outfits for each other, and then wear them in public for the rest of the day.

☐ Sing karaoke to a song you've never heard before.

☐ Bake a cake, frost it, and immediately plunge your face right into the top.

#randomactsofweirdnesschallenge

How can you encourage weirdness in others?

Did you know our bodies are composed of 90% awesomeness?

YOUR STRANGE
CREATURE MANIFESTO
What do you stand for, and what do you
intend to do about it?

ACKNOWLEDGMENTS

One day, while working at the day job I had at the time, I got an email out of the blue that would change my life forever. That email was from Marian Lizzi, my future editor; and I will forever be grateful to Marian for taking a chance on me, for championing weirdness with me, and for her expert guidance. I would also like to thank assistant editor Lauren Appleton, and everyone at Penguin Random House and TarcherPerigee for their help in making this ridiculous thing come to life. Thank you!

Enormous thanks to Rachel Beckwith of R Beckwith Design in Portland, Oregon, for her time and expertise in helping me digitize the handwritten typefaces for this book. Hooray Rachel!

Thanks to my parents for raising a total weirdo and encouraging her in all her weird endeavors (and mailing her a giant pile of chocolate at the eleventh hour!).

Thank you to my husband, Nate, for keeping me sane during this process in all the right ways (food, laundry, clean-ish house) and insane in all the right ways too (dance parties, late-night punch-drunk laughs, general mayhem). My weird world revolves around you!

Finally, to all of you who have cheered me on, and cheered on the things I draw, and cheered on my illustration business, The Dapper Jackalope: I can't thank you enough. I still can't believe I get to do this for a living and I'm grateful for it and all of you every day. Thank you!

ABOUT THE AUTHOR

Photo by Toni Osmundson

Kate Peterson is an illustrator in Boise, Idaho. She likes drawing monsters and making art that gets people of all ages thinking like kids again.

For more of Kate's work, follow:

@thedapperjackalope

www.thedapperjackalope.com